Address all inquiries to:
Barron's Educational Series, Inc.
250 Wireless Boulevard
Hauppauge, NY 11788
www.barronseduc.com

ISBN-13: 978-0-7641-6332-6
ISBN-10: 0-7641-6332-9
Library of Congress Control Number 2009932234

Printed in China
9 8 7 6 5 4 3 2 1

Gotta Love Dogs!

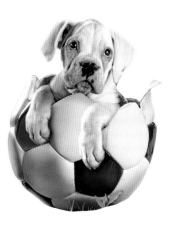

Kate Eldredge
Deb Eldredge

BARRON'S

dog's loyalty

Never wears thin

He will always love

Everyone near him.

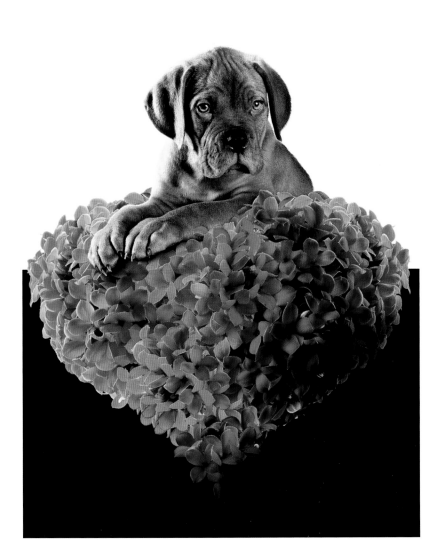

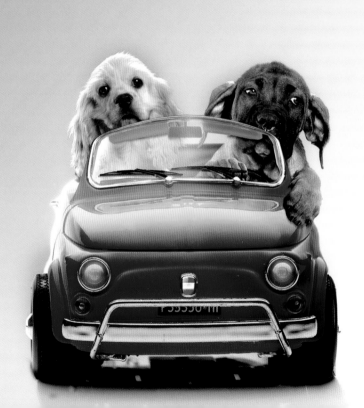

There is little better than the open road and a good friend at your side.

A new soccer ball might cost a few dollars, but those sweet puppy eyes are more than worth it.

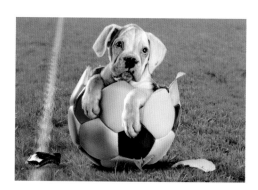

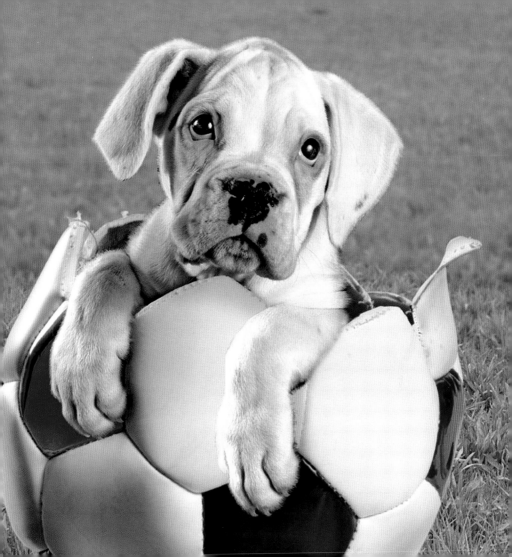

Dreams
not fished
for can
never be
caught.

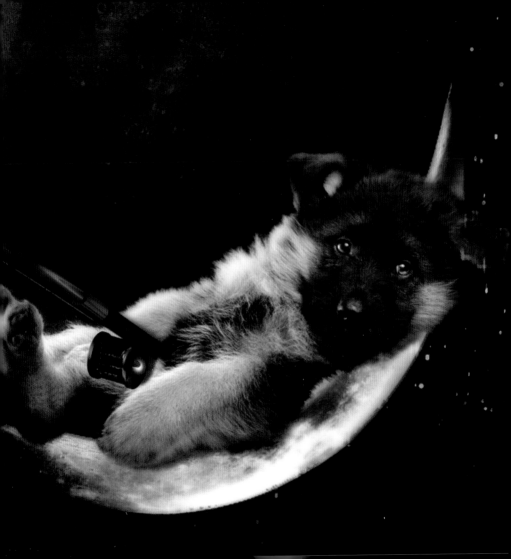

Live life as a dog does—

Jumping for joy just
because the sun is shining.

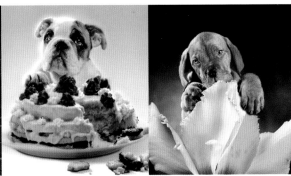

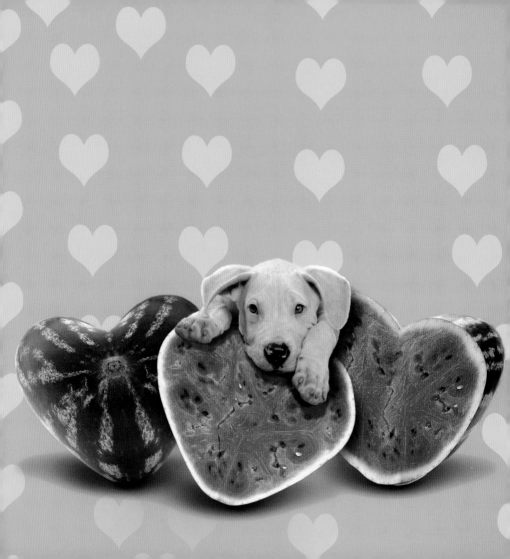

erhaps the puppy loves
you or perhaps he loves
the food you bring—
either way,
does it matter?

Sometimes I wake

up and wonder,

"Where am I?

And how on earth

did I get here?"

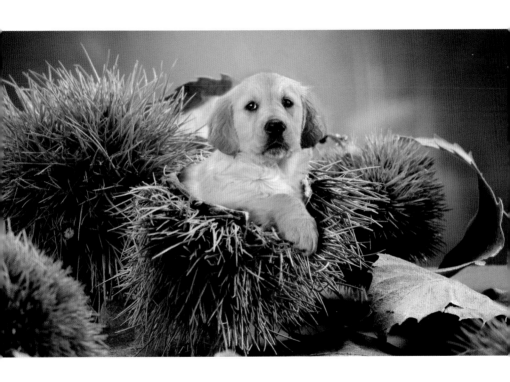

Wake me up
when the fun starts.

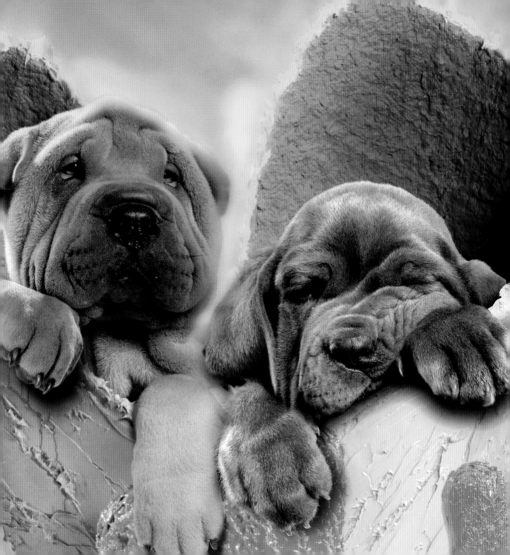

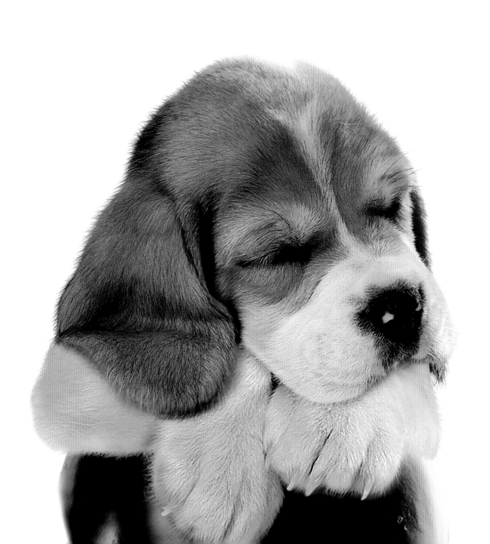

To know peace, just listen to a puppy breathing.

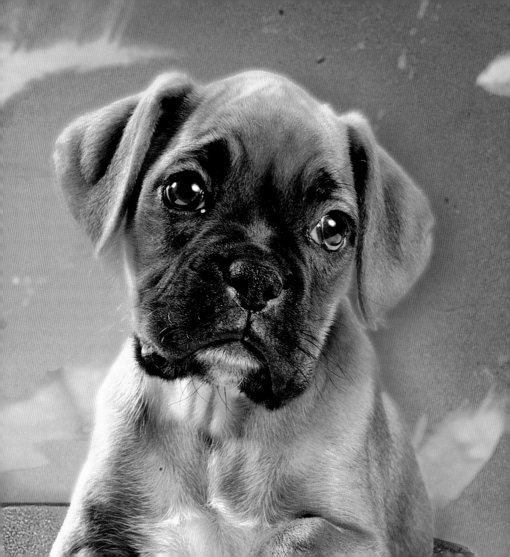

*A dog's eyes
offer a glimpse
into his soul.*

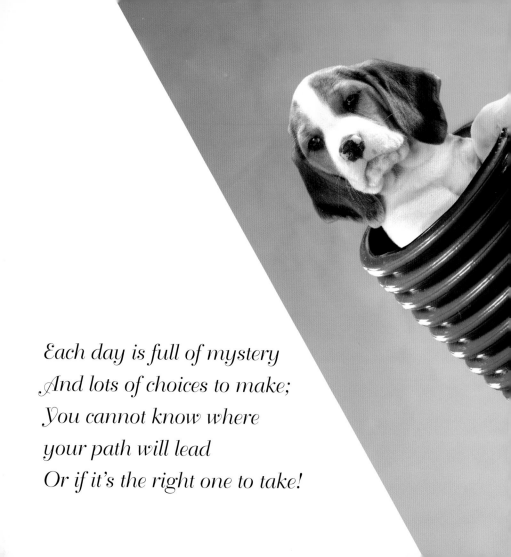

Each day is full of mystery
And lots of choices to make;
You cannot know where
your path will lead
Or if it's the right one to take!

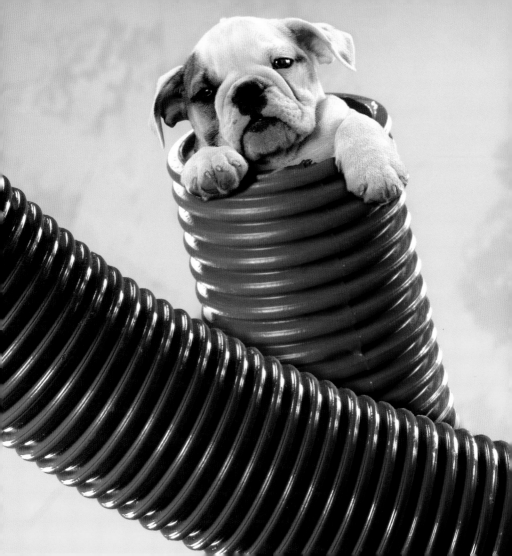

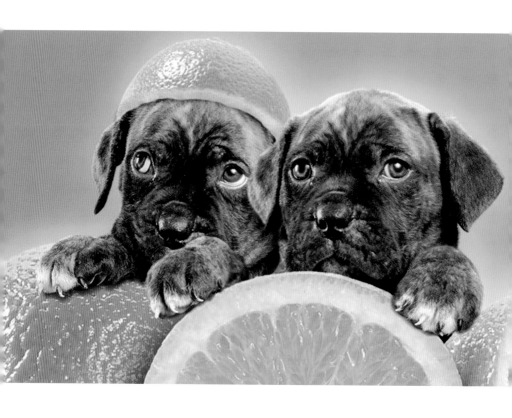

Never underestimate a

puppy's

zest

for life.

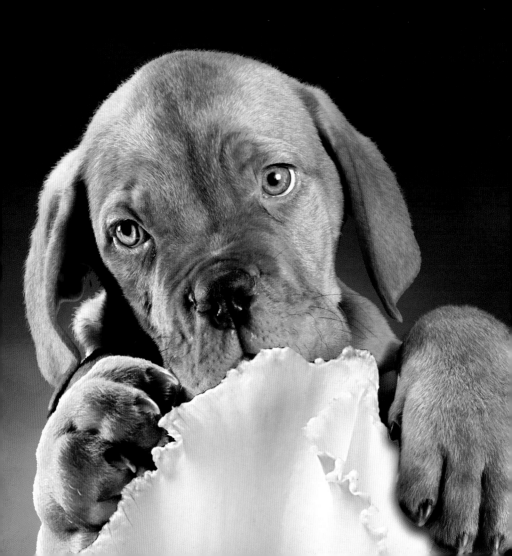

Remember

that dogs, like us,
cannot live unloved.

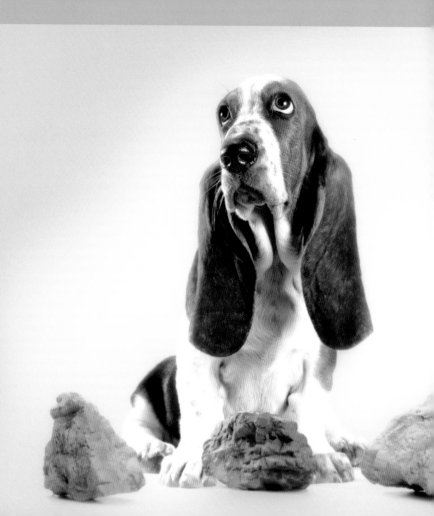

*A*s they say,
one dog's rock
is another
dog's treasure.

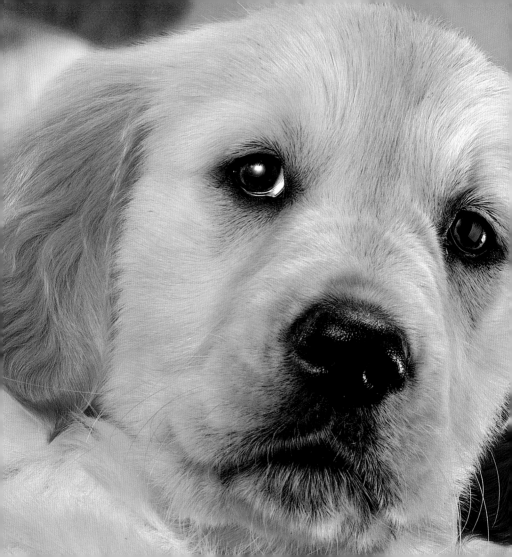

Your dog doesn't wonder where you've been or what you've been doing. He is just glad that you've come back.

Why yes,

I would love to join
you for dinner!

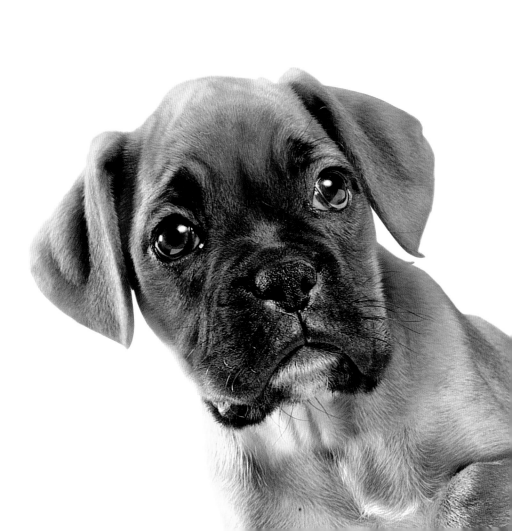

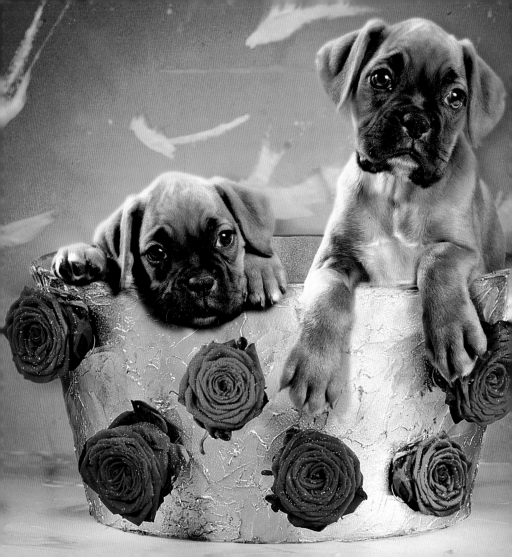

Gather ye rosebuds
while ye may—
Puppies don't smell
this sweet for long!

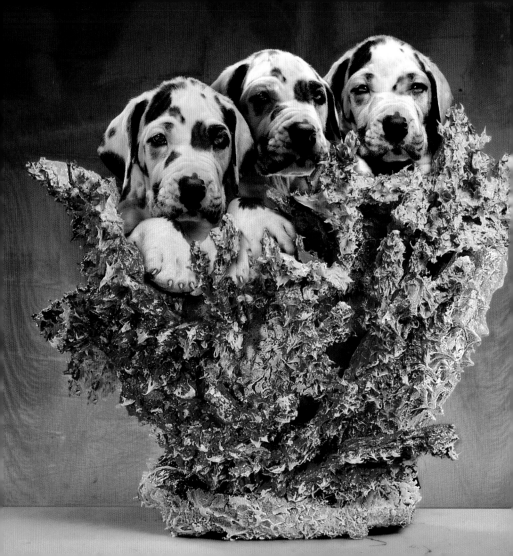

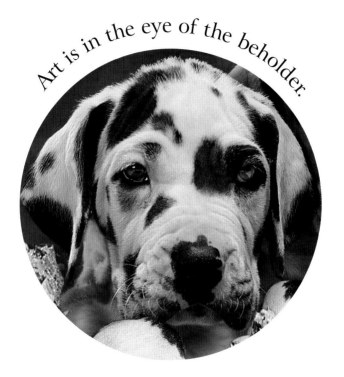

Art is in the eye of the beholder.

Pretty puppy,
Rest softly in sleep
For it has been a long day;
Dream of tomorrow
Of the fun we'll have,
And all the games
that we'll play!

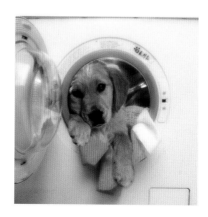

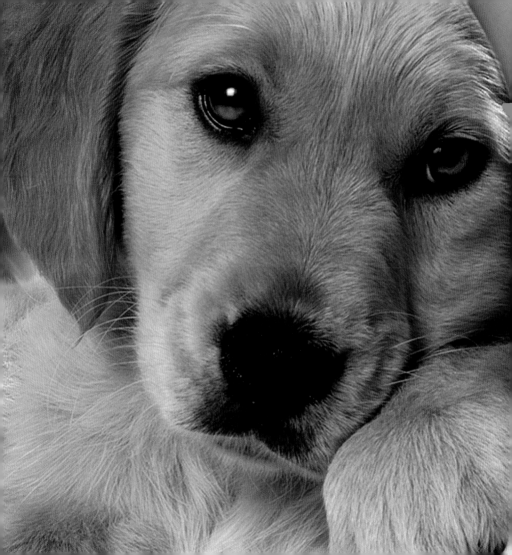

It's such a big world we live in

that sometimes you

just have to bark and say,

"Hey—don't forget me

down here!"

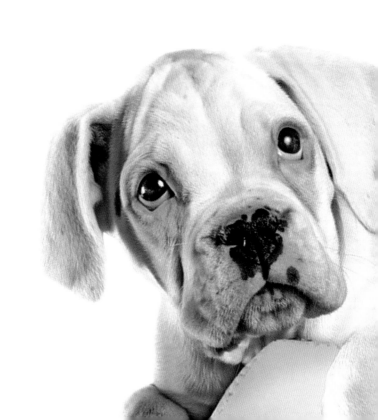

Being cute

is just so exhausting!

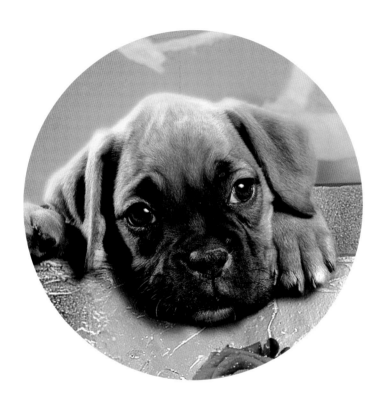

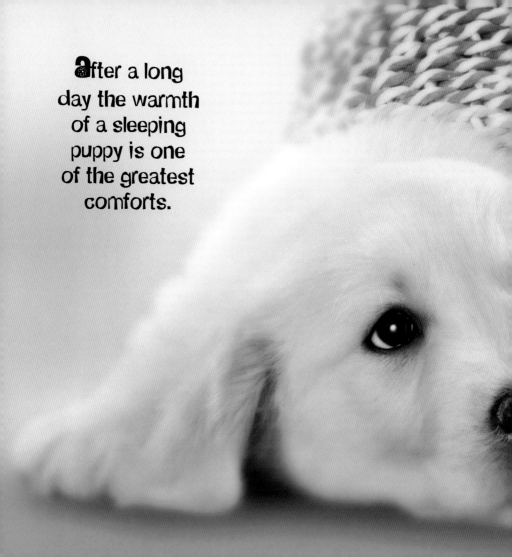

after a long
day the warmth
of a sleeping
puppy is one
of the greatest
comforts.

Is it dinnertime yet?

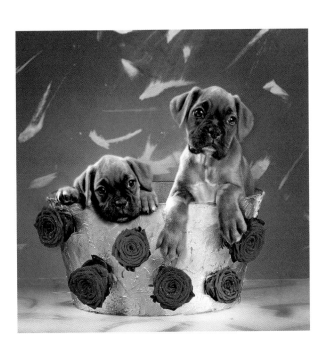

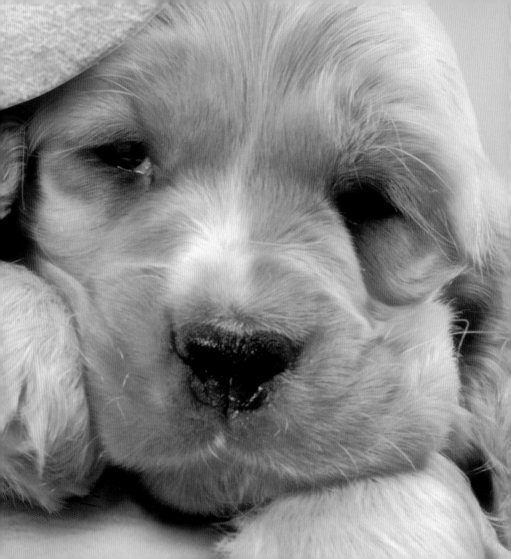

*D*o I *look* like a
morning person?

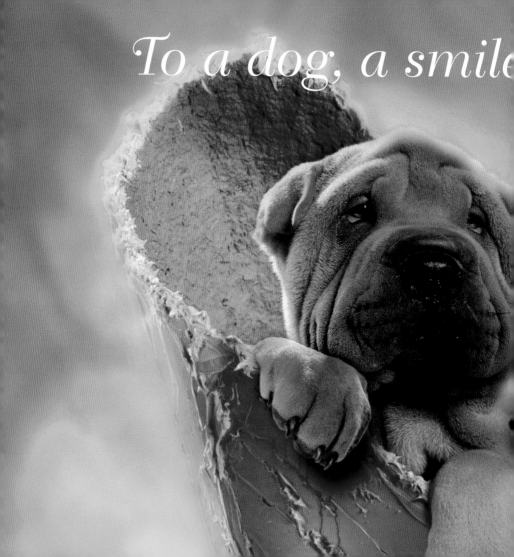

To a dog, a smile

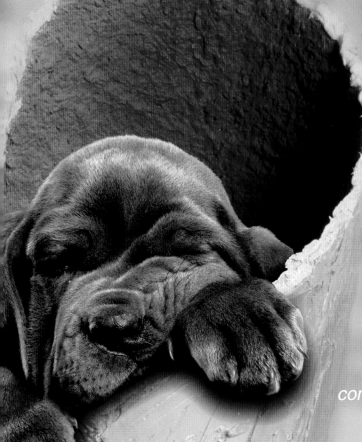

from his master...

continued...

...is the greates

of treats.

Lounging with big feet outstretched
The puppy waits, poised for play.
Ears flopping and eyes shining,
He's ready to face the day.

Who doesn't like a bubble bath?

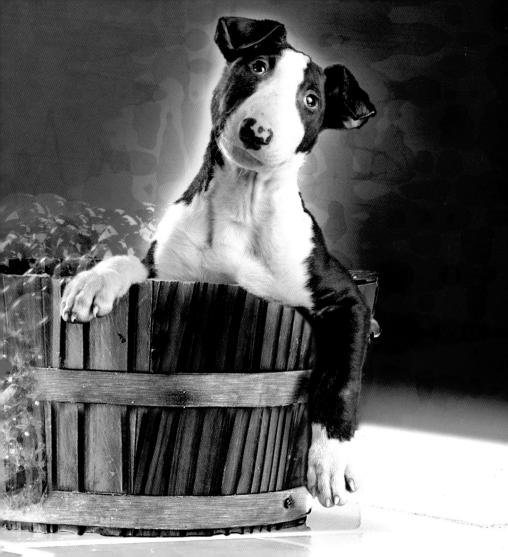

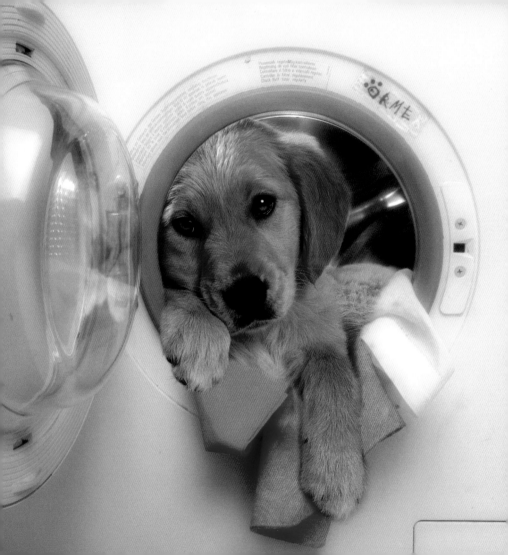

A girl's got to keep her coat soft and fluffy somehow!

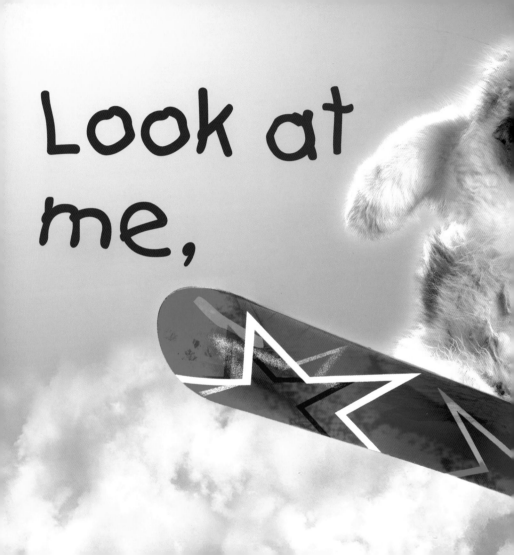

Look at at
me,

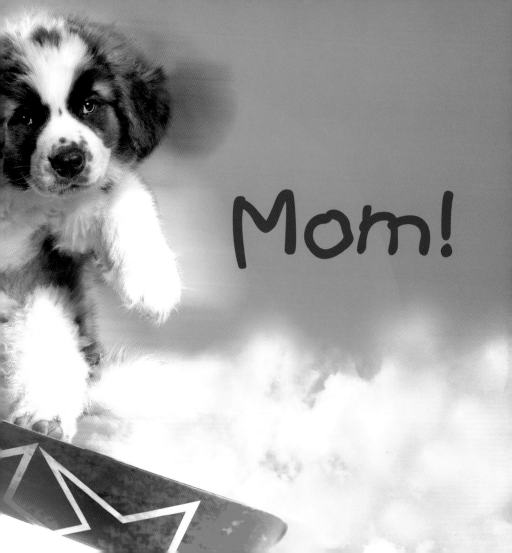

Mom!

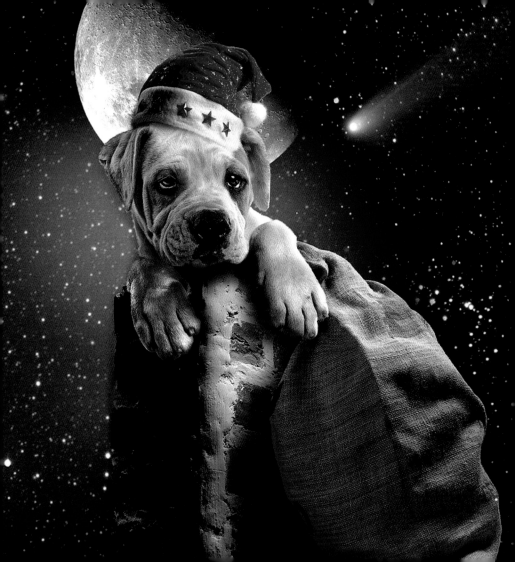

Merry
Christmas
my friend,

and may all
your gifts be
BONES!

The secret to happiness is simple—cherish each moment, and it will never leave you.

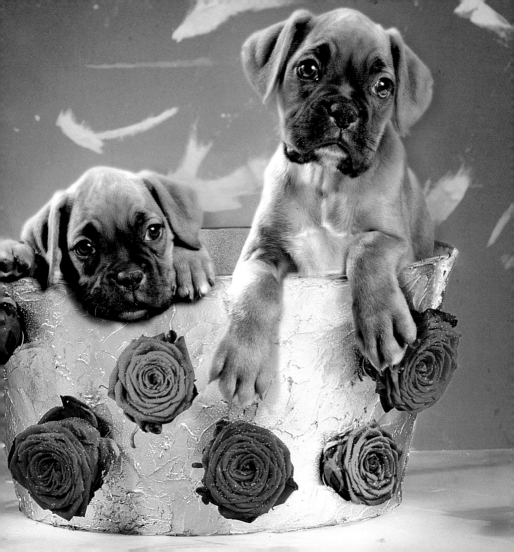

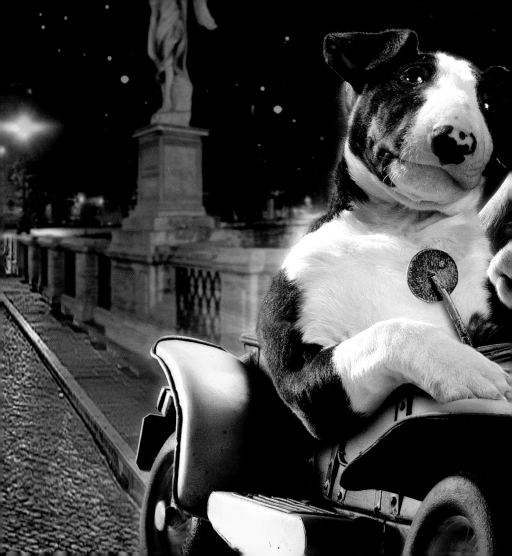

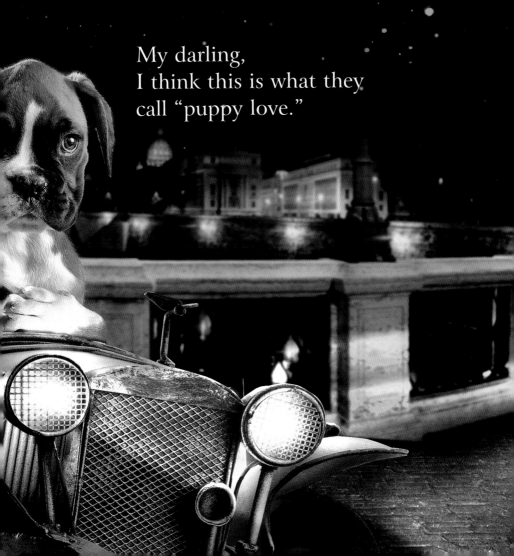

My darling,
I think this is what they
call "puppy love."

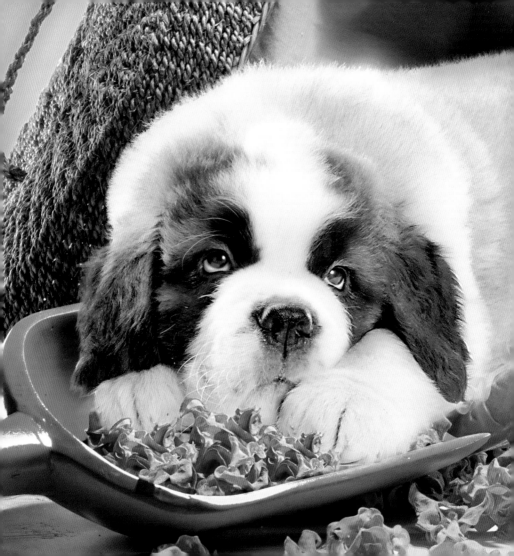

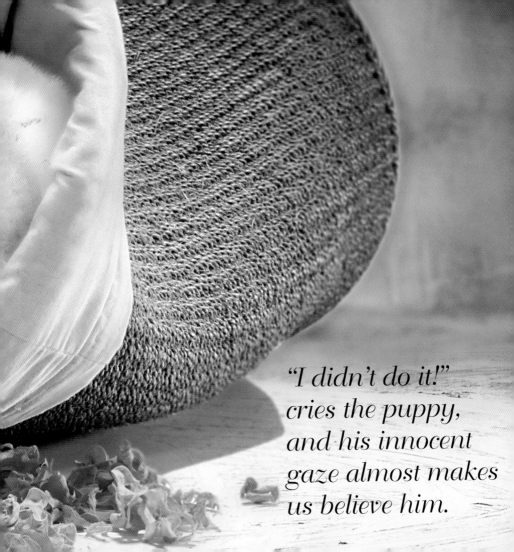

"I didn't do it!"
cries the puppy,
and his innocent
gaze almost makes
us believe him.

Wisdom can be found in
the most unlikely places.

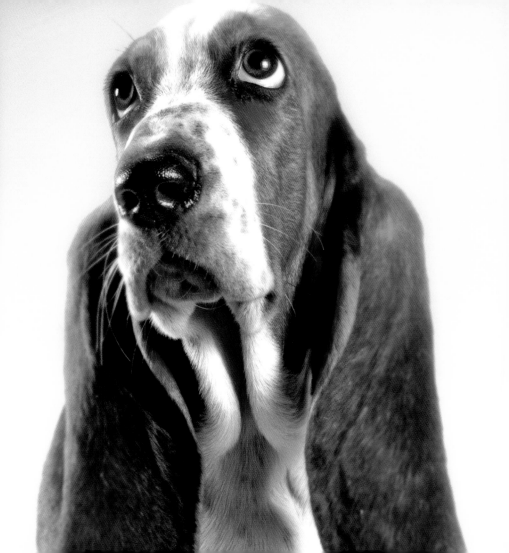

S peak softly,
but carry a big bone.

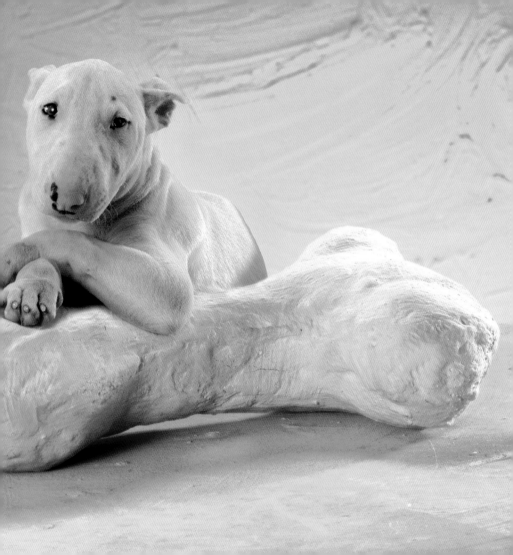

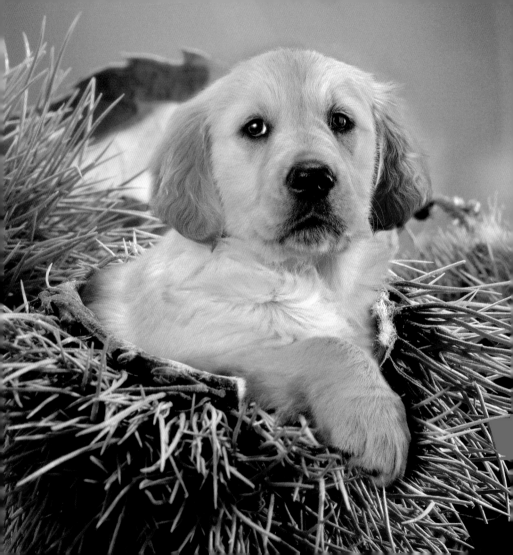

Could you bring me
breakfast in bed?

Violets are
blue,
Lilies are
pink,
What I did on the floor
Really does stink!

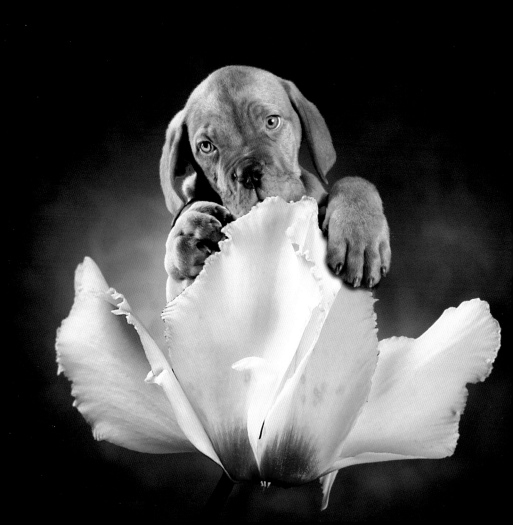

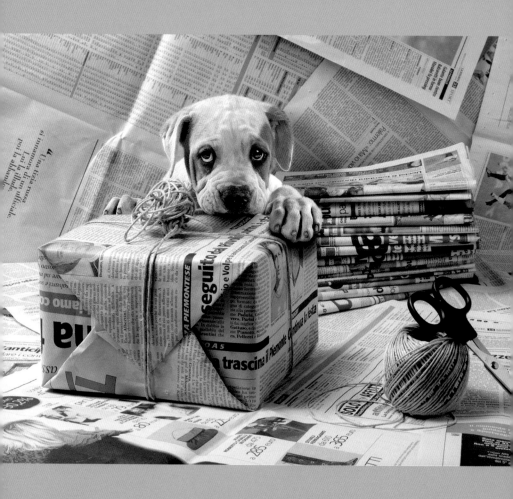

The wrapping job may
not be pretty,
The bow's not shiny and new,
But in the end what matters
most
Is that this gift's for you.

Of all the powers man possesses
Kindness is his best,
And when his heart starts softening
A puppy does the rest.

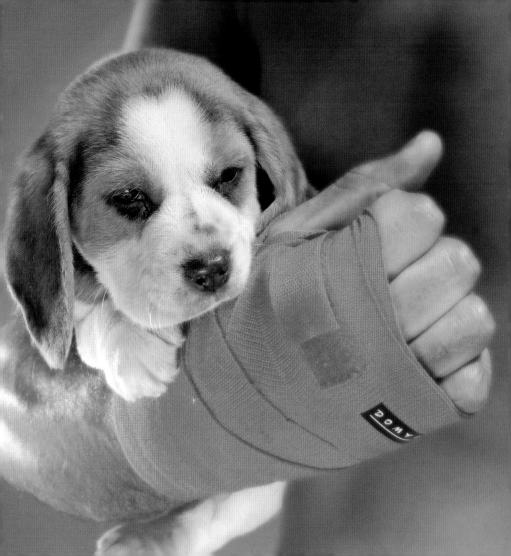

People say I'm simple-minded,
but I just have my priorities in line.
Why worry about the meaning of life
when I only want to know if it's dinnertime?

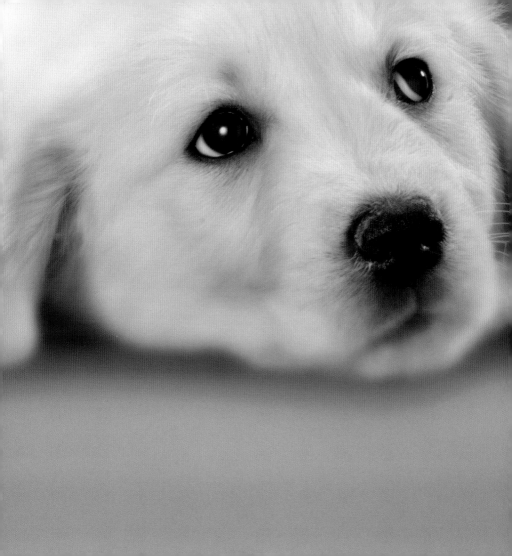

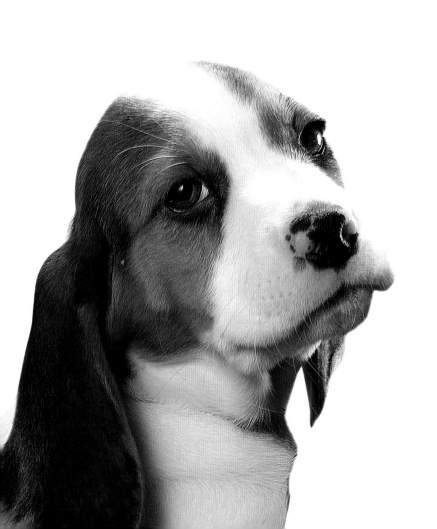

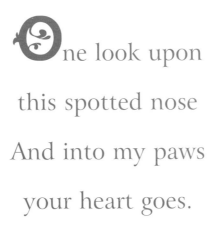

One look upon

this spotted nose

And into my paws

your heart goes.

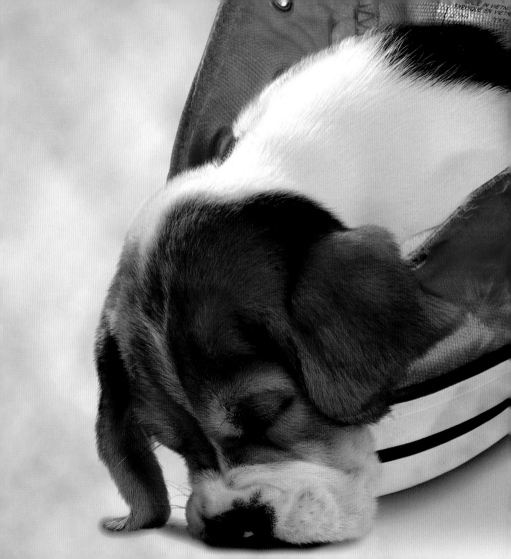

Perhaps this wasn't the greatest idea.

And how may I help you?

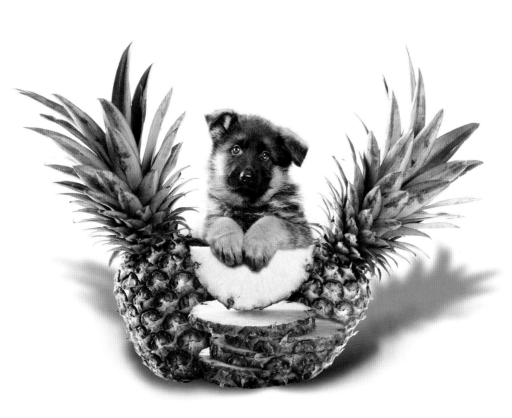

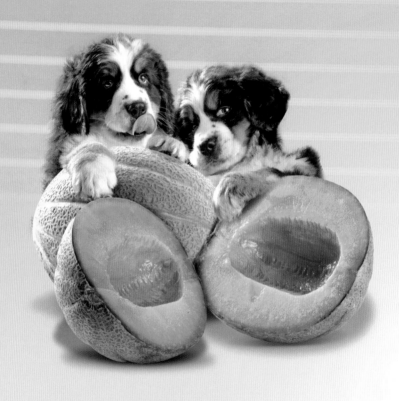

We've been called many things, but melon-choly we're not!

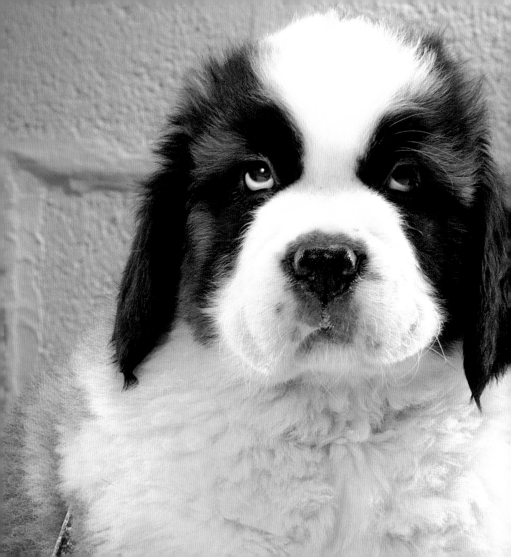

I swear,

the cat framed me!

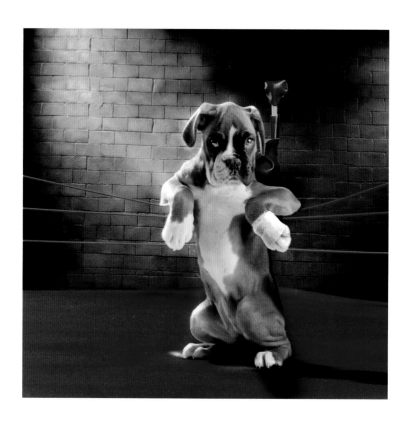

They say glory is fleeting,
but whether that's
true or not,
I am still the top dog.

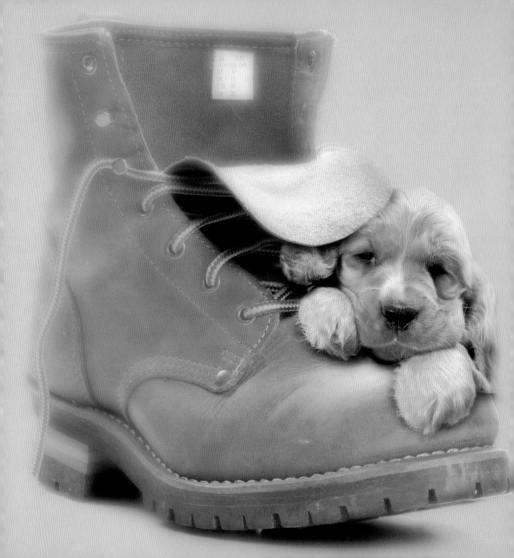

I'll eat it after my nap.

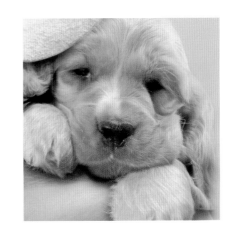

Sit? I don't

know sit.

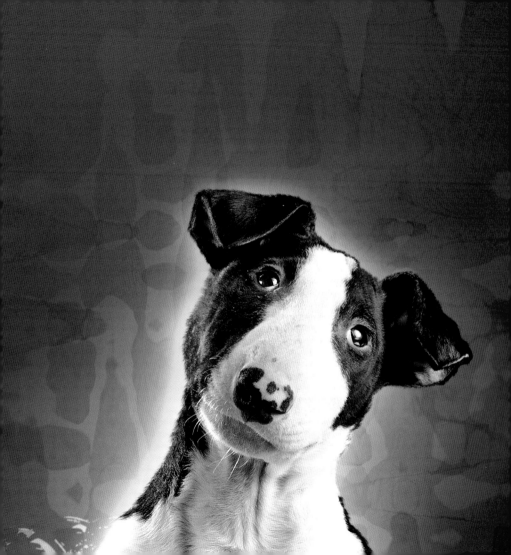

Don't

blink!

My philosophy is,
it's all about
balance.

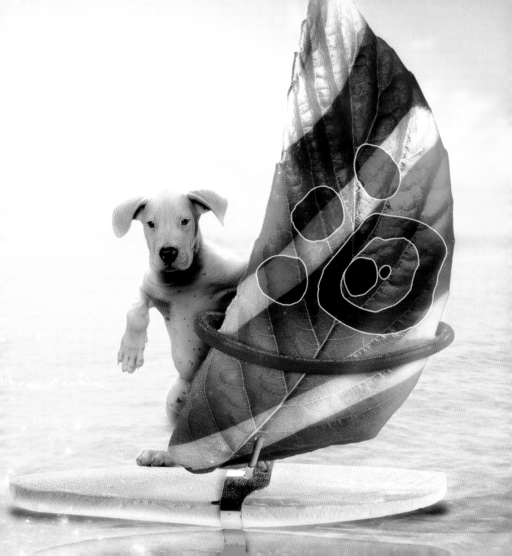

Take it from me:
Don't get too
wrapped up
in things!

What can —
I was born
to be a model.

It looks bad, I know, but I have a very good explanation!

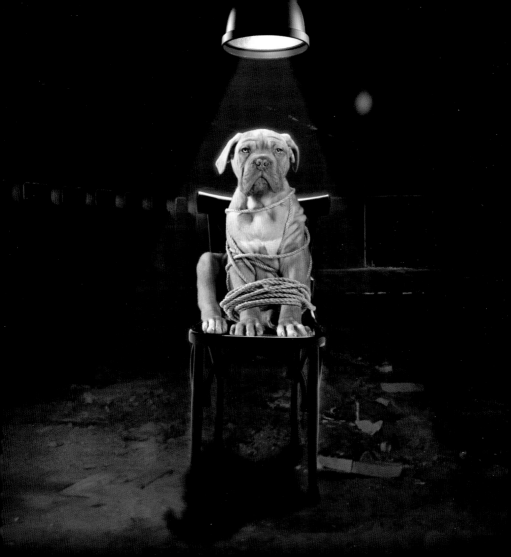

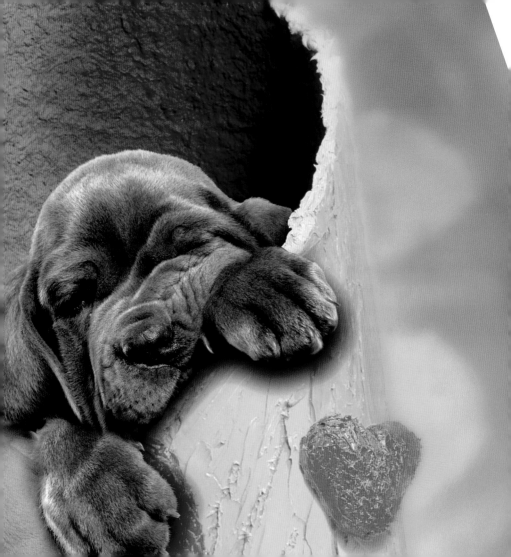

I just need five more minutes…

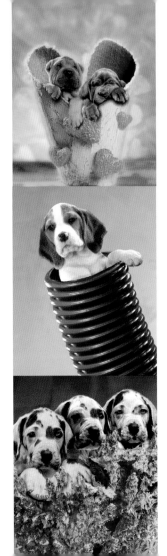

Though they come

in many shapes

and sizes,

dogs all love the same—

big!

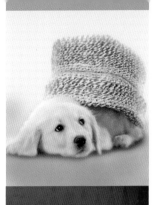

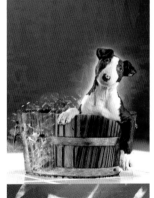

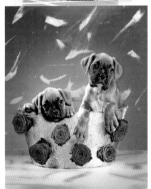

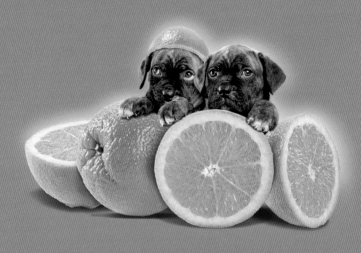

I *told him this*
wasn't a good hiding place.

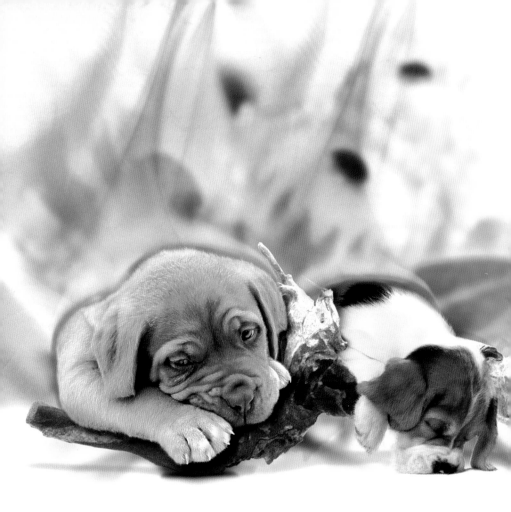

Excuse me, but we're trying to get our beauty sleep here.

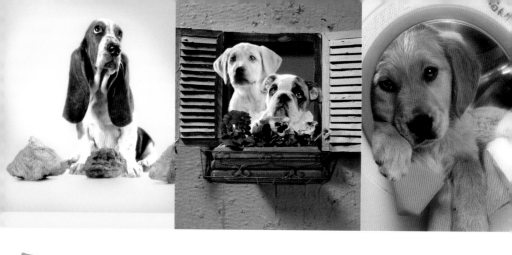

Puppies, puppies everywhere

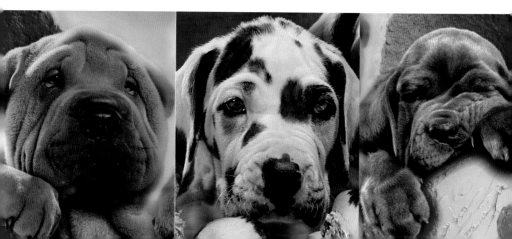

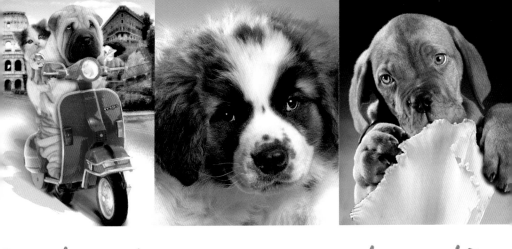

But oh! which one to pet?

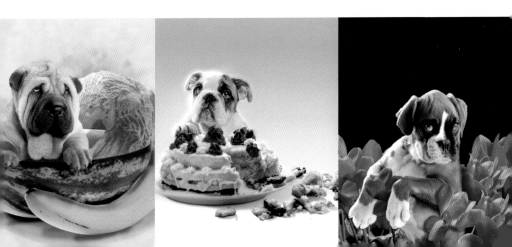

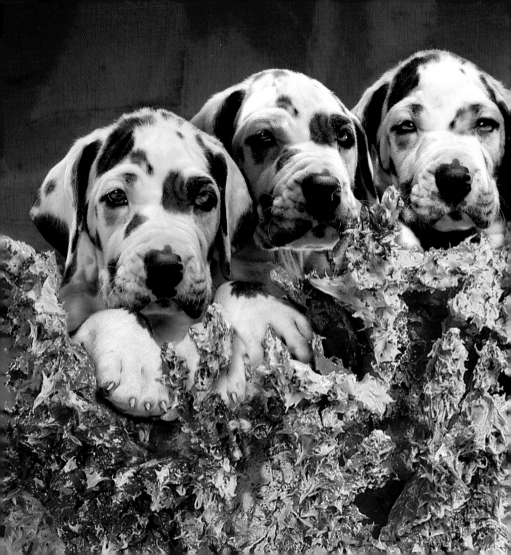

Who can
resist a
three-for-one
deal?

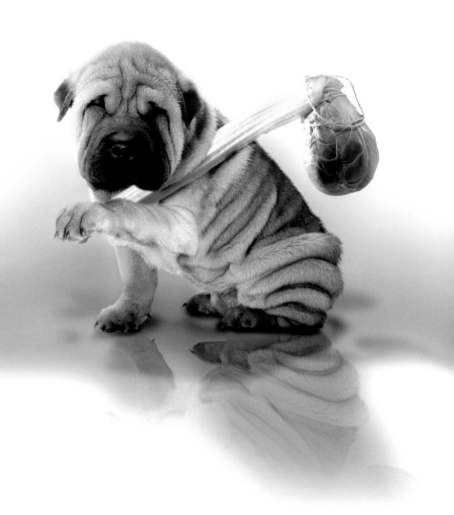

hink you could bring
ME INTO THE FOLD?

Puppy, puppy
Posed with cake—
Are you just tired
Or half baked!

I see ghosts.

Can't you see the stress I am under?

Doggone it, we make
a great team.

Why do we howl

at the moon?

For love of you!

puppy's youthful charms
Delight us every day,
For he is cute and cuddly
In every single way.

Though it
was lovely
seeing you,
now I am
quite tired.
So please
go away,
and let this
sleepy dog lie!